STICK
SKETCH SCHOOL

MASTERING THE ART OF THE
STICK FIGURE

BILLY ATTINGER
AND RACHEL KOCHACKIS

ROCKPOINT

Quarto is the authority on a wide range of topics.

Quarto educates, entertains and enriches the lives of
our readers—enthusiasts and lovers of hands-on living.

www.quartoknows.com

Race Point Publishing
A division of Quarto Publishing Group USA Inc.
142 West 36th Street, 4th Floor
New York, NY 10018

www.quartoknows.com

ISBN: 978-1-63106-061-8

Library of Congress Cataloging-in-Publication Data is available

Cover design by Billy Attinger

Printed in China

5 7 9 10 8 6 4

Not to be sold separately

Content originally appeared in the book *Stick Sketch School* (Race Point, 2014)

CONTENTS

INTRODUCTION

WELCOME TO STICK SKETCH SCHOOL!

I'm your instructor, Stick Master Bill Attinger, professional cartoonist extraordinaire and lover of stick figures, cartoon characters, and *The Princess Bride* (of course). In this book, I'm going to take you on a fun, artistic journey into a Stick World Wonderland, where I'll share my cartooning tips and secrets with you. Not a trained artist? It totally doesn't matter! The best part about stick figures is that *anybody* can draw one. All you need are a few shortcuts and techniques to make your stick figures as expressive, personal, and dynamic.

SO WHAT IS A STICK FIGURE?

Sure, on the surface a stick figure looks like a simple drawing: a basic shape with a few lines and a circle head—a sketch that's so easy, even a caveman could draw it. But don't let this superficial description fool you. With stick figures, it's what's on the inside that counts, literally, because stick figures are the "skeletons" of the cartoon world. That's right! Before they become those colorful, ultra-sleek 3-D characters that you see in your favorite movies and comic books, cartoons are stick figures first. Many cartoonists and animators use stick figure wireframes to sketch out the look, shape, and pose of a character before they add details and color on top of them. So, as you learn to master the art of stick figure design, keep in mind that you're actually practicing the beginning stages of cartoon development.

Pretty sweet, huh?

BECOMING A STICK FIGURE MASTER

So, how can you become a Stick Figure Master? Well, young stick artist, we've created several lessons to help you get there. As you journey through this book, keep in mind the following lessons that I've learned over the years, including:

SIMPLICITY. Life is like a stick figure. You can make it as simple or as complicated as you want. So, choose your path wisely and remember: Simple art can be just as effective as the fanciest art. In other words, it's not how many lines you draw, it's how you draw them that counts.

SELF-EXPRESSION. Creating stick figures is about expressing yourself through art. It's about talking with your stick designs instead of with your mouth. So, before you start drawing, think of the message you want to communicate. And then practice how to say it with your design.

LAUGHTER. The most important rule when drawing stick figures or cartoons is that you must be able to laugh at yourself . . . and at your art. Normally, if someone laughed at an artist's work, the artist would be greatly offended. But, a Stick Figure Master invites laughter as a positive sign that the art is doing its job. Art doesn't always need to be so serious, and it definitely doesn't need to be competitive. Keep it about having fun and spreading joy, and your art will go a long way.

WHAT YOU NEED TO GET STARTED

So, are you ready to dedicate yourself to becoming a Master of the Stick Figure Arts? Great! Let's go! Many of the designs that I created for this book were developed with acrylic paint and ink using paintbrushes and markers. So, feel free to use those same elements if you want to emulate the same rough look and thickness of my artwork. But don't be afraid to find your own style and experiment with other mediums, like pens, pencils, markers, crayons, chalk, a paintbrush, or even finger paint. You can't go wrong with any of those, and it's fun to experiment with new tools. Plus, by experimenting with different mediums, you could end up crafting a super personal and distinct art style that people recognize as yours. There's nothing wrong with that!

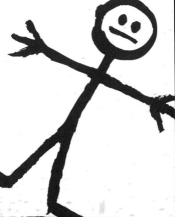

THE ANATOMY OF THE STICK FIGURE

Few things are as simple and easy to draw as the stick figure, but how can you make your stick figures effective at conveying a message? In order to answer that question, we're going to break down the stick figure design, piece by piece. As we look deeper, we'll try to identify the purpose behind the creation of each and every limb and suggest appropriate techniques that might help you identify your style. Yes, dissection sounds painful, but don't worry, stick figures are very flexible, so it shouldn't hurt a bit!

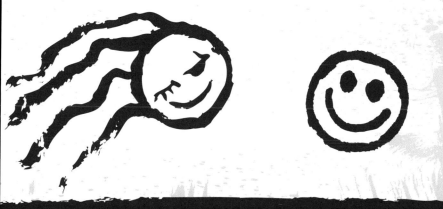

CHOOSE THE RIGHT BODY TYPE

Choosing a body type for your stick figure depends on what the occasion is. Is your stick figure attending a sporting event, participating in a beauty pageant, or going to war? Whether it's short or tall, thin or wide, you can usually give any character a solid foundation by using one of these three suggestions for the body: an oval, a triangle, or a line.

Ovals are great for showing size and strength, especially if you are trying to portray a larger character, like a football player, a wrestler, or even a monster. Ovals also provide a great space in which to add details to the body, like clothing, jewelry, and accessories, which work well if you are creating a uniformed character like a police officer, fireman, etc..

Triangles have always been a traditionally great shape for quickly identifying female characters, especially on restroom doors. But hey, this isn't your grandma's stick world! Today's stick girls are hip to wear anything they want, and a triangle can sometimes be very restrictive when it comes to creating fun poses. So, feel free to explore the triangle-shaped torso for your girl characters, but just don't get stuck in the Stickmuda Triangle.

Finally, there is the infamous stick line torso. When it comes to portraying thin, nothing beats a single-line stick body. However, this shape is more than just a quick fix; it also provides the most artistic freedom to create action, movement, and poses. If your stick figure is going to be on the move or striking a pose, then it's a stick body you want.

GOING OUT ON A LIMB

Okay, so now that you've got some different bodies for your stick figure, ask yourself, what is my stick figure doing? Any action or lack of action will be portrayed in the stick figure's legs and arms. Is my stick figure running, jumping, standing, posing, or flying? Whatever they're doing, the stick figure's arms and legs are the key ingredients to illustrating both body language and emotion or feeling: arms crossed to show stubbornness; arms up to show confusion; legs crossed while seated to show relaxation. All of these things need to be considered when adding appendages to your subject. Let's review some examples below.

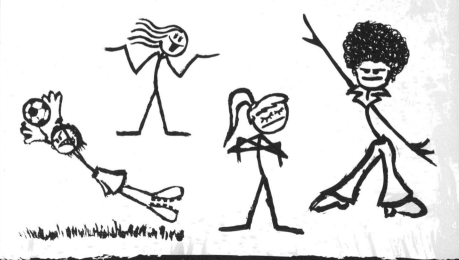

GETTING A HEAD
OF YOUR STICK SUBJECT

Now it's time to get ahead, so to speak. Yes, we're talking about your stick figure's literal head. The look, style, and shape you choose for your stick's noggin will say a lot about their character. For example, a large, round head could communicate that the stick figure appears "chunky," while a thinner, oval-shaped head might be more appropriate for a skinnier character. Slanting an oval head is a great way to portray action or movement in a particular direction. But no matter what head shape you choose, nothing will put your character over the top, better than what YOU put on top of it. Of course, I am talking about hair!

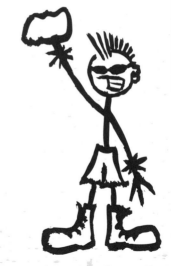

HAIR AND THERE

Hairstyles say a lot about a person, and they say a lot about stick figures, too! Unique hairstyles can really spice up a stick figure and are essential tools for portraying unique traits and personalities. Using the right hair and hair accessories can also be a great way to identify age, era, occupation, gender, and even origin. So whether you're rockin' a Mohawk, pigtails, or a geeky bowl cut, your stick figure's head and hair will be essential parts of your character's story. Check out some of the unique hairstyles on the stick figures below and see what they tell you about each character.

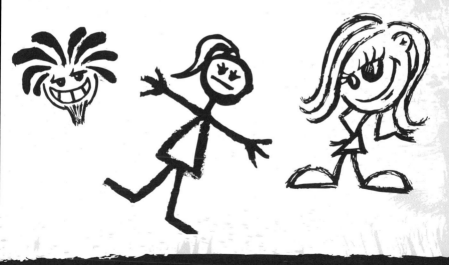

FACE CASE

It's a face-off, err, rather, face-on, as we finally take a glimpse into your stick figure's psyche. The eyes might be the window to the soul, but a stick face can reveal more about its character than a gossip columnist could ever dream of! Take a good look at the faces featured on the stick figures below. What are they thinking? What are they feeling? How can you tell? Is it in their eyes? Mouth? Eyebrows? All of the above? You see, your stick character can turn from Crazy Mary to Saint Mary depending on how you illustrate her face.

STICK BODY LANGUAGE AND EMOTIONS

The most effective stick figures can speak volumes without uttering a single word. They display their voice just by the way they look and pose.

So now that you've become familiar with the parts of the stick body, it's time to let your stick bodies do the talking! Stick figures can be moody, expressive and rowdy. Here we'll explore the art of conveying some different attitudes using simple and subtle body poses.

Stick figures are also emotional creatures that can literally wear their hearts on their sleeves. Just like you, they can feel a range of emotions—from happy and sad to scared and excited. Whatever emotion or mood they may feel or be in at a given moment, you should be able to take a quick look and know what they are thinking and feeling.

COPPING AN ATTITUDE

Whether sweet or sassy, stick figures just love to show off their attitude! It's in their nature. And as you draw them, they can express your attitude, too!

So what does your attitude look like? Whatever it might be, it can be expressed in many different forms of stick body language. It can be a simple show of confidence, perhaps by standing tall and proud with chin up and a confident smile. Or it can take on a sarcastic feel with a roll of the eyes or a crossing of the arms.

Try sketching a series of stick figures in different poses in the Stickworld™ Sketchbook, each one illustrating attitude through body language. Finish them up by adding messages or captions into a thought bubble above each character.

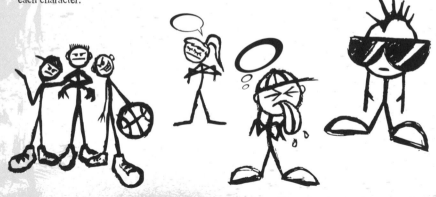

STYLIN' & PROFILIN'

You can't always explain it, but when someone is confident, you just know it. Many times you can see it in the way they present themselves. We call it swagger, and as we try to infuse our stick figures with some swagger power, it helps to try and imagine what makes them so confident. Knowing why will help you draw it!

No matter the source of confidence, it is key to show off that source as much as possible by featuring it prominently in your art. For example, if a stick figure has confidence in his or her looks, then show her brushing her hair or posing in flattering positions that best show off her attributes. If a character is confident in his or her physical abilities, like an athlete or superhero, perhaps you can illustrate him flexing his muscles or standing in a physically intimidating pose. And finally, if a stick figure gets his confidence from a material possession, then you definitely need to sketch them posing in a way that shows off the object as much as possible. Like a stick chick flashing a diamond ring, her hand waving dramatically in the air. Or a stick dude leaning up against his flashy new car or hiding behind a sweet pair of shades.

COME ON GET HAPPY

Happiness and joy are essential to living a good life, and stick figures are great at spreading that joy to the rest of the world with their fun expressions and joyful body language. Whether it's learning to ride a bike for the first time or celebrating a birthday, when something good happens, stick figures can't keep it to themselves—they have to tell it to the world! Take a good look at several happy expressions, and then you can practice emulating that joy with several characters of your own.

Take a look at these happy examples below. First, look at the face: notice how the size of the smiles can express just how happy they are. Next, look at the eyes: can you see the joy welling up in them and how simply that can be accomplished with a pen or pencil? And finally, examine at the body language: what do the actions and angles of the body say to you?

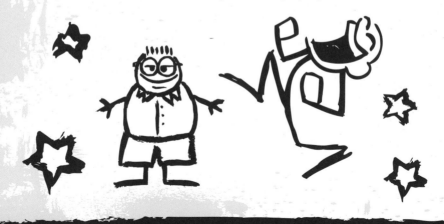

ANGER IS ALL THE RAGE

What ticks you off? Whether it's the result of your favorite team losing the big game, stubbing your pinky toe, or getting cut off in traffic, anger is a normal emotion that finds us all at one time or another. And because there's so much stuff to get angry about, sometimes we need to get creative in finding new ways to blow off steam. Well, say no more! Here's your opportunity to get out a little rage! Our stick figure friends are ready and willing to feel your wrath and absorb your pain in order to help you come to grips with expressing your anger in art.

Take a look at the angry stick figure below. Do you see the clenched teeth, the furrowed eyebrows, the little black smoke wisp coming off the top of the head? The clenched fists and forward-leaning body are strong body language indicators for anger. It's almost as if the stick figure is storming right off the page or ready to confront someone or something. What other details or embellishments do you think would add to the visual clues of an angry-feeling stick figure? Rough, scribbled lines are a subtle detail that can add to the chaotic feeling of anger in your stick art.

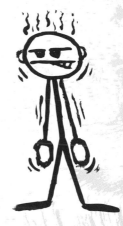

HOW TO MAKE A
STICK FIGURE CRY

In life, there is a lot of heartbreak and hurt—painful moments that can rip a little stick heart right out. But fear not! Everything's going to be okay, because you have your stick friends to help you get through the tough times

Take a look at the mournful stick figures below. What visual clues tell you that these stick figures are sad, depressed, or despondent? Sure, there are the obvious tears, but do you see the eyebrows that are drawn in the opposite angle of the anger eyebrows? Sagging limbs and a lowered head are great techniques to use if you really want to send your stick figures into a full depression.

Pay attention to the visual clues that create a deeper level of despair for your stick figure. Try adding accessories, like tears or even a thought bubble to indicate why they are sad.

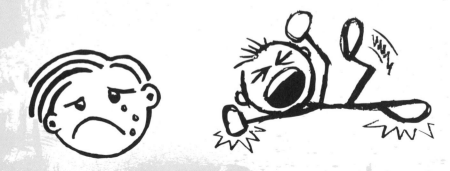

LOVE STRUCK

Now, when the love bug bites a stick figure, it can start with something as simple as an interested glance that manifests itself with puppy dog eyes and a dreamy smile—innocent enough, right? But at other times, stick figures feel the love so deeply, their little stick hearts pound right out of their little stick chests—literally! Floating hearts can indicate that these poor fools have been transformed into desperate, love-starved maniacs! These love-crazed stick figures can be identified by their klutzy behavior, such as tripping over their own feet when that special someone walks by, as well as their large, wide eyes and unpredictable smiles. You know those crazy smiles: the ones that make you wonder whether or not it's safe for you to stick around!

Are you ready to fall in love . . . with your stick figure? Using our examples of love for inspiration, create your own lovesick stick figures. Pay attention to the accessories, like floating hearts, and visual clues, like huge eyes and maybe even a heart beating out of the chest to increase that level of passion.

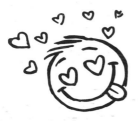

CRAZY IS AS CRAZY DOES

Welcome to the stick world asylum!

Take a look at our stick figure in the example below. What visual clues show their craziness?

Notice the large eyes and smaller pupils. Does it seem like he is looking off into another land? Is he over-caffeinated or just plain crazy? Devious smiles or hand-wringing can also indicate degrees of instability if drawn effectively.

Okay, it's time to get crazy! Create your own crazy stick figures, ranging from a little hyper to a straitjacket-wearing Hannibal Lecter. Add some different details like thrashed hair or two eyes looking in opposite directions. And include some accessories like oversized or undersized clothes. Sometimes the smallest details can really elevate the level of insanity in your stick figure.

STICK SAFARI

Welcome aboard, animal lovers! We have scoured the world to put together the most amazing stick animal safari. From Australia to Africa, we'll explore the many different genres of animals as categorized by our own personal stick science. So, if it's feathered, scaly, hairy, or slimy, you'll probably find it here. But before you start to nod off, don't worry—this isn't biology class! It's art class. And classifying and drawing a stick animal is a lot more fun. So, let's start dissecting!

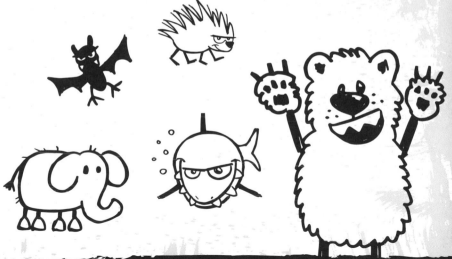

FURRY AND TEXTURED

Now, fur and hair come in a variety of different textures and colors, but our scientific stick geniuses have broken them down into three simple categories: the Fluffy, the Hairy, and Don't Touch Me! With the fluffy textures—like those of sheep or llama—we use a soft, billowy texture that is easily identified by rolling, curly-cue lines. On the hairy textures, we use quite a few different techniques, including zigzag lines, like those seen on a horse, lion, or giraffe mane, or the unfinished paint brush edging that you might see on a bear or bunny. And for the only-slightly hairy mammal, like a hippo or elephant, we've deployed the use of randomly placed hair follicle patterns that will remind you of a leg that hasn't been shaved in a few weeks. Lastly, we've reserved the Don't Touch Me category to identify animals that have a not-so-cuddly texture, including the porcupine, hedgehog, and even some of the spiny anteaters.

SCARY AND SLIMY

Think about the grossest creature you've ever seen: Does it scare you? Does it make you sick and disgusted to think about touching it? Ding! Ding! Ding! We have a winner! The creature you're probably thinking about fits right at home in the Skareeus Grossa Slymius stick family. Maggots, roaches, tarantulas, worms, killer bees, frogs, and rabid kindergarteners are all included on this safari of the macabre! You'll be sure to see lots of slime, fangs, long and hairy legs, and more on this particular tour, and no, we're not talkin' about your grandma's house!

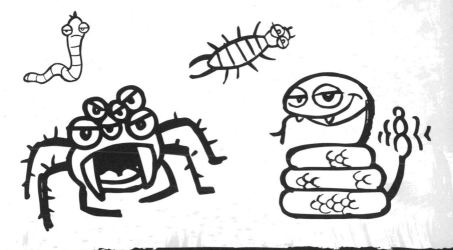

SPOTS AND STRIPES

This stick family includes all animals with a distinct design or pattern. Zebras, cheetahs, and leopards fit nicely in this family, as well as clown fish and even cows. As you explore these multi-patterned stick animals below examine the various degrees of line thickness used to create the detailed spots or patterns featured on them. What look do you prefer? Do you like filling in the spots and stripes with solid color, the kind of effect achieved with a thick marker? Or do you prefer more detail offered by a thin pencil or marker?

Given the variety of patterned animals out there, imagine you're sketching an energetic zoo scene with zebras, cheetahs, leopards, and cows running wild. This is a good opportunity to experiment with different tools so get pencils and markers ready to create different effects with your patterns.

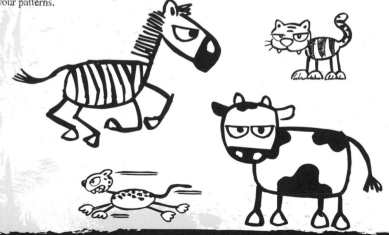

THE STICK WARS

What is stick war? Stick war is an every-man-for-himself battle royale where each player takes turns drawing different stick warriors and creating new ways to attack his or her opponent. It's a great way to create action-packed stick drawings with friends. Here's what you will for each stick war:

A Battle Location: Your Stick World™ Sketchbook will do.

• A Drawing Weapon: Use the markers, pencils, or colored pencils included in this kit.

• A Willing Opponent: You can play by yourself or with friends.

• Rules of War: Rules? There ain't no rules, just a few simple steps.

STEP 1: THE LANDSCAPE
Draw a cool backdrop for your battle.

STEP 2: THE WARRIORS
Player 1 begins the battle by drawing the first warrior.

STEP 3: ATTACK
Player 2 then takes a turn by drawing one of their own warriors attacking Player 1's warrior. Each player continues taking turns, drawing one new warrior and one new action—either an attack or defense—per turn.

NINJA WARS

Few warriors are as stealthy and crafty as the ninja. In addition to being martial arts masters, these silent figures are also masters of the sword, long staff, nunchakus, and, of course, the throwing star. Let's put your stick figure art skills to work and capture some sweet stick fu action poses in our first stick war.

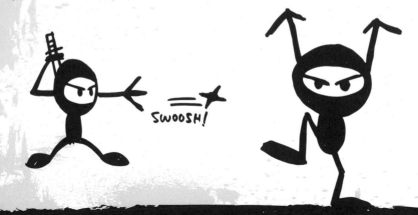

SWOOSH!

Ready to Fight?

STEP 1: THE LANDSCAPE

First, you must establish the terrain. Literally. Where do your ninjas fight? If you are in Japan, maybe try drawing Mount Fuji in the background or adding some Japanese-style buildings with curved roofs. Feel free to turn up the difficulty by adding two cliffs on each side of the paper, separated by a deep chasm. The possibilities are endless.

STEP 2: THE WARRIORS

Of course, ninjas are well known for wearing their masks. So, to create a stick ninja, simply draw a sideways oval in your stick head with two eyes showing. But what are some other ways to distinguish your army of ninjas from your opponents? You can try adding unique features, like a sword slung over the back, a headband or belt, or the unique ninja-style split-toed boots. One very popular method is to use a unique insignia or logo to mark your army. For this stick war lesson, let's keep it simple and we'll battle with the black ninjas versus the white ninjas.

STEP 3: ATTACK

Okay, now it's your turn. Once you've designated the terrain and selected your warriors, you can begin your stick fu ninja war. Start by having either you or your opponent draw a warrior and then have the second player attack them. Continue taking turns until you run out of time, paper, or patience. Take a look at some of these unique warriors and weapons below for inspiration.

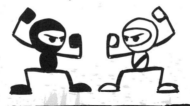

HEROES VS VILLAINS

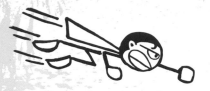

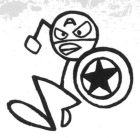

Holy Toledo, stick man! The stick world is in peril and you must choose sides! Will you join Captain Stickmerica, Iron Stick, and the rest of the Stickvengers as they fight the evil forces that seek to use their super-erasing powers to rub out the stick people of Earth? Or will you join the dark forces led by the evil geniuses Stick Joker, Stix Luthor, and Stickneto? Find an opponent and create a superhero stick war using stick heroes and stick villains with the most super elements that you can imagine.

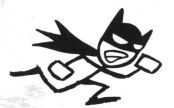

Ready to Fight?

STEP 1: THE LANDSCAPE

A major metropolitan cityscape like New York is a perfect landscape for this! But any big city with tall buildings and innocent people will provide a great place to let good and evil duke it out. As you choose your location, keep in mind that you can depict any place in the world by including a major world landmark in the background, like the Statue of Liberty, the Pyramids of Giza, or the Eiffel Tower.

STEP 2: THE WARRIORS

Caped stick fighters, masked crime spree-ers, flying figures, or water-dwelling warriors are just some of the ideas you can use to create your crew of good or evil. Note: Capes can be easily created by adding a triangle shape to the back of the neck of each character. See the super stick heroes for inspiration on outfitting your hero and then create your own super stick heroes!

STEP 3: ATTACK

Okay, it's time to save the world! But how will your heroes and villains manifest their superpowers in art form? There are lots of options. Maybe you can draw your stick hero flying in the air, shooting a laser from his or her eyes, or lifting a car with superhuman strength. What else can you come up with? Let's find out. Ready? Wonder Stick Powers activate!

STICK BATTLE ROYALE!

Okay, the gloves are off! In this trailblazing lesson, we will abandon all conformity and rules that limited us to a specific time, place, or theme and have a free-for-all style war. Your imagination will be your guide! Drawing on all of your training, you and your opponent(s) will battle using any style of warfare to create the ultimate stick battle royale. But—and this is truly where the "no rules" part of stick wars really reaches its apex—you are not bound by any of the specific classes of warfare covered in this booklet. In fact, you don't have to use any of them, unless you really want to.

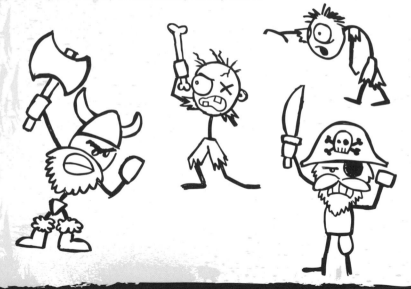

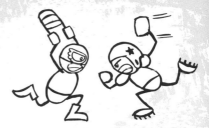

Ready to Fight?

STEP 1: THE LANDSCAPE

Mount Rushmore, the Moon, Sesame Street, or Congress, whatev! Any place you can imagine is where you will fight!

STEP 2: THE WARRIORS

We're not going to lead you this time! You have earned the right to lead the fight. Now go and build your own unique army of stick soldiers! Who would you choose to fight on your team? Zombies? Athletes? Celebrities? Relatives?

STEP 3: ATTACK

Okay, Armageddon is here, and it's time for you to bring the Stickpocalypse.
Think outside the box and put together the most unique stick war you can imagine using anything and anyone as inspiration!

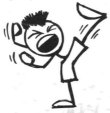

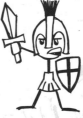